MW00889836

"QUALITY BEADS"

And Other

CLOTH NAMES

A Translation of *Ahene Pa Nkasa*,

Akan Poems Based on
the Names of Ghanaian Cotton Prints.

Ofori-Mankata

© Michael Ofori-Mankata2014
All rights reserved. No part of this publication may be
reproduced, stored, in a retrieval system, or transmitted,
in any form or by any means, electronic, mechanical,
photocopying, recording, or otherwise, without the
written prior permission of the author.

Type and layout by: Seth Nana Brako
 Dennis Amoako
 Kwame Ofori-Mankata

Printed in the United States of America

ANSAA READS LLC PUBLISHERS
174 GRUMMAN AVENUE SUITE#1
NEWARK, NJ 07112
(973) 856 - 7804
http://ansaareads.weebly.com/
www.facebook.com/ansaareads
www.amazon.com/Michael-Ofori-Mankata

**We dedicate this book
and its original Twi version**
Ahene Pa Nkasa

to

**His Excellency Mr. Kofi Annan
and his beautiful wife Nane,
Invaluable Treasures of the World**

CONTENTS

PREFACE

Ghanaian citizens like to wear cloths, but due to the fact that it is considered more ceremonial than practical, they would wear Western suits to work in the offices and factories. However, on occasions when they want to project their culture, men wrap their huge cloths around them and women also wear their skirts and blouses and use pieces of the same cloth for the beautiful headgear. Superb!

There are special occasions for Kente and Adinkra, but Dutch Prints popularly known as "Dumaase" or "Dutch wax" is what the people wear every day at home or for church and other outings. Over a century ago, cotton prints were copied from Indonesia and manufactured in Holland and Britain and exported to West Africa. Today many prints are made in Ghana and other West African countries, at places like Tema and Akosombo. There are also inferior and cheaper prints made in China to adulterate the market.

The interesting thing about Dumaase is that every popular print has a name even though the manufacturers identify them by numbers. Modern prints that have no names are grouped together under the brand name "Awurukutam".

Some prints are named after the designs in them. Some are named after events that took place when they first appeared on the market. There are prints named after special people and others are tagged with some Akan Proverbs.

If something happens in the society, people can choose to wear prints to show how happy, sad, or disgusted they are about that incident. Such silent demonstrations are very powerful and effective.

I am very much fascinated by the names of our cotton prints. Some of them remind me of our history, while others help me to improve my speech and writing in Ghanaian Languages, by using some relevant Proverbs. Some names provoke philosophical thinking.

These poems are based on the names of some of our cotton prints in the Akan Language and translated into English. We hope reading them will encourage our friends to take more interest in our colorful cotton prints and see if they can encourage other people to like them too. Perhaps looking at this project will encourage them to do some of the following things:

1. Name a particular print and ask your friend to name another.

2. Go to the markets and make a list of all the prints you can name. Ask the cloth-sellers to help you with more names.

3. If you meet someone wearing a print, ask him/her kindly to tell you the name. Start a friendly conversation.

4. Find out why a particular name was put on a cloth.

5. If a cloth is named after someone, read or learn about that individual.

6. If it is named after a place, plan a visit.

7. If you find a nameless print, you may suggest a name for it and explain why.

8. Make an artistic design for a new print and name it.

9. Make an album of cotton prints and put names on them.

10. Write your own short stories or poems about your collection of prints.

11. Sew your pieces of prints together and use it for making a new shirt, skirt or dress.

12. You may use little pieces of print to decorate your notebooks, files or folders.

ACKNOWLEDGEMENTS

This work could never have taken place if there were no cotton prints on the market. We are therefore greatly indebted to all the cloth-makers in the world, especially the ones in Indonesia, Holland, England, Tema and Akosombo, whose samples inspired us to write the original anthology of poems in the Akan language and title it: *Ahene Pa Nkasa*.

Our special thanks go to Auntie Esi, owner of Makola Elements Trading Store number 53 in Accra, Ms. Debora Quartey of G.T.P Tema, and all the other lovely ladies who taught us the names of various cotton prints. Seth Nana Brako, Dennis Amoako and Kwame Ofori-Mankata worked very, very hard to copy the prints and type the poems.

The English translations were begun by our dear friend and colleague Mr. D.E.K Krampoh who worked tirelessly with us until his untimely demise in 2011. We shall always remember him and the great interest he took in this particular work. May his soul rest in peace. We are also most grateful to Professor Kofi Asare Opoku, Professor Kofi Agyekum, Mr. E. Apenteng Sackey of The University of Ghana, Legon, and all the many other friends who edited, encouraged, and helped us to complete this project. They remind us of two Akan Proverbs:

"Dua koro gye mframa a ebu" – The single tree that receives the storm, breaks.

" Woforo dua pa a na wopia wo"- If you climb a good tree, you are pushed up.

Very heartfelt thanks!

Michael Ofori-Mankata

AHENE PA NKASA

(1) QUALITY BEADS DON'T JINGLE
(AHENE PA NKASA)

1. Abyssinia merely glitters
Because it is light it screeches
Because it is so good, it soon gets bad
When it touches your teeth
they get set on edge.
When it is round your neck,
It irritates the skin.
When worn on the ear,
It creates a sore,
But ahene pa (quality beads)
don't talk.

2. Those that mother gave me
Have become old and a little darkened,
Yet they don't rattle around my waist,
And my wrists don't
corrode under them.
When this one sees them,
they say they want some;
Yet another asked,
"Where did you buy them?"
And Nii Smith the craftsman says
I shouldn't take them off
For anyone to wash them.
The quality beads
that market themselves,
don't jingle.

AHENE PA NKASA

3. Let Akua Frefre spin and twirl,
And Kofi Sumpii somersault.
When kakapenpen firmly settles
And Akyenkyena takes the floor
When the needle's eye gets blocked
And the thread unravels,
Control yourself,
Maintain your position,
It was not today that you were strung,
Quality beads don't jingle!

4. If a quality bead doesn't talk
About the cut of his hair
He is given a bad hair cut,
and he shaves off entirely.
If today we are all dumb exiles
Then it's because the quality beads
did not jingle.
It is true that Nsawam
is the destination
Of quality beads that dare to jingle,
Yet, when quality beads
shut their mouths,
Auschwitz is the station of this dark,
black train,
So quality beads, occasionally do talk,
you hear?

ANI BERE A, ENSƆ GYA

(2) WHEN EYES TURN RED,
 THEY DON'T BLAZE SPARKS
 (*ANI BERE A, ENSƆ GYA*)

1. If it surprises people that
 Amidst all this storm and fury
 You're able to go and come,
 And do all that's required of you
 Without running amok and barking
 Bow, wow like a dog,
 Tell them humbly, soberly that
 When the eyes turn red,
 They don't blaze sparks.

2. If you fall dumb
 Before your assailant
 And don't call your supporters
 With any urgency,
 As Agya Kwasi often does,
 If they don't understand
 Why you don't cough,
 Don't clear your throat noisily,
 Don't swear on Wukuda and Sokode,
 Because of the ram's horn
 that you have,
 say; When the eyes turn red,
 They don't blaze sparks.

3

ABC

(3) THE ABC LETTERS
(ABC)

1. How is A pronounced? AAA!
 How is B pronounced? B
 How is C pronounced
 when we don't have it?
 But D is pronounced D.
 ABC is the beginning of knowledge;
 We learn their names and pronunciation,
 We write them, read them,
 and even sing its song.

2. I don't know the Portuguese Language,
 I can't read the Latin books
 of the Romans,
 And the history of the ancient Greeks,
 I don't know.
 Knowledge about nature and climate
 change,
 If I hadn't gone to *Amanfo*
 how would I know?
 The only calculation I make is that
 involving the *Cidi*
 I did not go to *Legon*, yet I know the ABC.

3. Squeezing your face shows anger,
 And laughter reveals love.
 If the beast won't bite you,
 It won't be grimacing,
 Showing you its teeth,
 Yet, it's the one who wants to look red
 That scratches itself against the mound,
 The lesson in good living is ABC.

ATWA ME BENKUM

(4) YOU'VE DONE ME IN
(ATWA ME BENKUM)

1. It was the two of us that set this trap,
And we agreed to inspect it
on a certain day,
And use whichever ophan we get from it
To prepare soup, and eat its entrails too.
If before that day could arrive
you go to the trap alone,
My brother, you would have done me in.

2. Kick the ball to *Baba Yara* on the
right
That he may kick it to *Gyamfi* at centre,
He too would let *Amadu Akuse* get it,
He dribbles turns and kicks it
to *Osei Kofi*,
Salisu is ready, waiting at *Kokofu*,
But why have we thus done him in?

3. He makes my greetings dry up,
yet it doesn't matter.
From the right side of the courtyard
he sends me condolences.
He sends some to those far off too,
And they respond
Akudonto and *Ahenewa*.
He sees *Kwasi*, looks the other way,
does him in,
Maybe, there might be
some matter or other.

BONSU

(5) THE WHALE
(BONSU)

1. It is not a fish, yet it lives in water.
It is very large,
larger even than the *Esono*,
Yet it has no feet to stand on;
Bonsu you who break up a ship,
you are terrible!

2. Living in the depths,
resting and breathing on the surface.
A good mother who suckles her young,
And carries it on her back
as does *Maa Akua*.
Bonsu, you who break up a ship,
you are terrible!

3. Because you are big
your brain has great depth,
The extent of your knowledge
goes beyond *Oguaa*.
Great is your bulk,
yet you feed on small fishes.
Bonsu, you who break up a ship,
you are terrible!

4. You are huge, yet are not wild,
A ship that is blind
and passes on your back,
You raise yourself and frighten it a little,
Bonsu you who are big and still loves the
family, You are terrible!

KƐTƐ PA

(6) GOOD MAT
(KETƐ PA)

1. Any known reed-mat,
or a raffia-frond one,
Spread on a wide-space floor
Sheltered from rain and sun,
Makes you forget that days
worries and tiredness.
So when you lay your head on it,
close your eyelids,
Stretch out your legs (if you choose)
Put your fore arm under your head
(if you choose)
The fast sleep that sets you
on the homeward way,
Even if it continues to *Koransan*
Stems from nothing but *kete pa.*

2. Any kind of spread (*popo, kyakya*)
blanket or mattress,
Iron bestead, earthern or wooden one,
The one with hard top or deep softness,
And many large and small pillows,
With a mosquito netting peaking above.
Because you will make my head
lie between two stones,
So that I can play my pipe *hoohoo*,
And sink into a good dream
that doesn't end at *Pitri*,
"I shall return to you O Love,
That you put me on a good mat."

AKYEKYERE AKYI

(7) THE TORTOISE SHELL
(AKYEKYERE AKYI)

1. I'm not fleet of foot, I walk slowly.
I know neither skipping nor jumping,
And the race of the hare
is not pleasing to me.
But by slow motion I return
to where I belong.

2. Because I'm not wild I don't bark.
I don't cry, make any noise,
don't harass.
Left to me and my friend *Otope*,
There won't ever be any
gunshots in the forest.

3. It's since creation that I've been
living under thickets.
Odum and *Duabo* are my age mates;
They indicate their age
by their annual rings,
Raise their heads;
reel up into the high heights.

AKYEKYERE AKYI

4. Snail shell, is crushed thoroughly,
And my little ones suffer every day.
When the enemy attacks,
there is no saviour!
Even when they shout,
no one hears their voice.

5. Wherever I sojourn,
I carry my room.
Wherever night overtakes me,
I obtain a sleeping place.
And if enemies turn to be many,
I tuck my head and my legs
into my *chamfron*.

6. The back of the tortoise,
unbreakable vessel!
It's not for any worthless
adolescent to crack.
It shows age and maturity,
experience and tact,
Self reliance, strength and patience.

9

ASUBURA

(8) THE WATER WELL
(*ASUBURA*)

1. A greater part of the human body
Is blood and water mixed,
So to be able to stand on your feet,
And do what you must, with strength,
May be, to fast a number of days,
To pray for direction and progress,
But, drink a lot of water in it all.

2. Good, clear water is very important,
Water trapped in buttress roots
is what some prefer,
So a good friend may offer
the one a calabash of it,
But as for me, what I like most,
is water from a deep-dug well.
Cold and very clear in quality,
Water from hand-dug well
calms the heart.

ASOBAYERE

(9) THE SMOOTH-SKINNED YAM
(ASOBAYERE)

1. There are many different
types of yam.
There are big ones and small ones too.
Some are white inside
and others are dark.
Some have thorny skin, like *ahabayere*,
And others are smooth-skinned.
Which ever type you like,
I'll cook for you.

2. Boiled *Pona* exudes
a very fragrant scent.
Nkani is spongy-sticky
and takes a long time to cook.
Water yam, fish and *Nyoma*,
Nkamfo that has cooled after boiling
goes with hot pepper.
Asobayere, the valiant,
without any dirt,
Toast it in the fire
and by it make me happy.

GYE AKONGUA

(10) THAT'S A STOOL FOR YOU
(GYE AKONGUA)

1. You've sharpened your lips,
 there's salt under your teeth,
 You've taken a *donno,*
 and borrowed a gong in addition.
 Because of a raised public rostrum
 And the cronies that you have,
 Haranguing and disgracing others
 is your job,
 But as for me,
 I have no power whatsoever.
 Because I have been mute,
 If you will really
 spread slander about me,
 Then, brother, sister, take a stool.

2. Say how I tottered and fell,
 And my lying in the mud
 in disgrace.
 Say the heavy fine that was laid on me,
 And the streaming tears
 that drenched me.
 But if you will remember rise after fall,
 Dirt, danger,
 and forgiveness purgation;
 Debt repaid,
 and tears that have been wiped,
 And talk, talk, talk about me,
 Then, brother, sister, take a stool!

AFE BI YƐ ASIANE

(11) SOME YEARS ARE DIFFICULT
(AFE BI YƐ ASIANE)

1. Each year and its events,
 This is why each *Ɔpɛpɔn*
 We go on our knees,
 And beg from *Ɔbɔade*
 Guidance and grace
 With which to make our journey
 Into the new year,
 And render thanks
 In the *Ɔpɛnimma* month.

2. Some year is misfortune itself, so
 It rains when we do not expect it.
 And the sun so shines
 That dryness occurs in *Oforisuo*.
 The corn which may have germinated
 Dries up completely
 And yam-cuttings in mounds
 Come up to nothing.

3. Some year is misfortune itself, so
 The cold that came
 Brought no fish catches.
 So the oars of fishermen ran aground.
 The *Mangoase* market didn't prosper,
 And the okro from *Kwamɔso*
 Had no market.

13

AFE BI YƐ ASIANE

4. Some year is a misfortune itself, so
 Subtractions outweigh the additions
 And throw all calculations out of gear.
 The one climbing falls down
 And the ladder he is climbing also
 breaks.

5. The new *Pharaoh* who came on
 Knew nothing of his history
 So he pursued you in the Red Sea,
 Because some year
 is truly a misfortune itself.
 But, Rod of Moses,
 you've conquerred.

6. The sun gets darkened
 And lamps go off,
 Making people think
 that all hope is dashed.
 But don't be discouraged.
 When things turn stony,
 some year will be yours
 And so wake up to hop and grab.

OFIE MMOSEA

(12) THE HOUSEHOLD PEBBLE
(OFIE MMOSEA)

1. They are pebbles, just pebbles,
 not rocks.
 They are in the house, in the house,
 not in the streets.
 You see them always, day and night,
 So presumably you know
 where each one lies.
 You have walked on them daily,
 And made them smooth.
 Making them even more beautiful
 than those from the Shai Hills.
 Yet when house pebbles hurt you,
 It is more painful than that
 from a cut by street pebbles.

2. They are in the family,
 they are not strangers,
 They live with you, and toil with you.
 They know you very well,
 your comings-in and goings-out.
 You don't fear them,
 and they do not shy of you.
 When you are eating,
 They put their hands into the bowl.
 When you drink from their cup
 You don't fear,
 This is why a cut from a house pebble
 Is so very painful,
 And also takes long to heal.

NANTWI BIN

(13) COW DUNG
(NANTWI BIN)

1. The cow is a big animal.
And its build it really great
When it twirls its tongue around grass
It cuts the grass valiantly,
chews and swallows it,
Then much later, it chews the cud.
Its four-apartment stomach causes
Cud-chewing to continue even in sleep.
After being filled with food and water,
and cud-chewing,
Its udders fill with milk
which is squeezed out.

2. When *Kwasi Nantwi* sets out
after a meal,
He would want to ease himself.
He wouldn't knock,
or undo a loin-cloth,
Whether in the street,
or in the market,
Kwasi eases himself tamtam, tamtam,
Cow dung tumbles out of his behind.
It is only Indians who know
of the fire in cow dung!
In no time at all the top- surface
Dries up beautifully,
But underneath the excrement remains
wet and offensive.

NSUAEHUNU

(14) HOLLOW SWEARINGS!
(NSUAEHUNU)

1. You are bigger than me,
And are an *Odogo,*
For your big shoulders
And their sheer strength,
Everybody fears to cross your path,
Anger you or inflame your passion.

2. As a result
You have suppressed us all,
And made us cower in your presence
like children;
Should this one cough you say:
Mayi bo!
Should another sing,
it's an insinuation!

3. "You'd see what I'd to you
instantly!
I'll beat you till your mum's belly
wriggles;
If you don't know about me ask Kwasi,
I'll stop your stepping out,
So you stop going to school."

NSUAEHUNU

4. *Ahɔɔden Mɛnsa*
who uproots the rattan,
Stalwart Atlas who holds
the whole world in your bossom;
Ataala, at whose shout
thunder clouds form,
Susono, whose step on the ground
makes the earth quake.

5. *Alaba Mansa* didn't go to *Ɔboase*,
yet she is sick?
We're looking for someone
To push *Nyanawa*,
Scoop or dredge *Korle's* waters
And scour the bed.
We're calling valiant men,
oh where're you?

6. If you cannot help
with your staff/paddle
To save the citizens
From persecution and tiredness,
Then spare me your threatening,
Because rumbling sounds
don't frighten me!

DUA KORO GYE MFRAMA A...

(15) WHEN THE SINGLE TREE RECEIVES THE STORM
(DUA KORO GYE MFRAMA A...)

1. Air is important for breathing,
Mountain-top is cool, and sweet.
It makes the fire burn
And makes trees grow.
If you stop breathing for a short while
And the air within you runs out,
Your sleeping place will be the floor.

2. But the Creator's good plan
Is that we aid trees and seedlings
with our breathing,
In connection with
their photosynthesis and growth.
And in turn they purify the air for us
Which we breathe into us,
That blood may circulate in us
to ensure we remain alive.

3. When air blows strongly, it is a storm.
So a big tree standing in the way
Helps to block the swathe
Of the storm's destruction.
It forces the storm
To change it's direction,
But a single tree,
without any other behind it,
Breaks when it
constantly receives the storm.

19

WOAFA ME NWAW

(16) YOU'VE EFFORTLESSLY GOT ME
(WOAFA ME NWAW)

1. If you touch *Antwiwaa*
 She cries *quaa quaa*
 clucking for everyone to hear.
 The lamb who fell silent didn't cry
 So the Owner
 Didn't hit you with his staff.
 Goat who cries *bee bee* would make
 people hear of you.
 She would make them run after you.

2. *Ɔtwe Agyanka* (Antelope orphan)
 Earns the bullet or the fence trap.
 Okwaduo, on his part, says,
 "You lie very much!"
 And *Aduoku* says,
 "There is fire on the mountain."
 With sharp claws and sharp teeth
 In *Etwie's* make-up
 How dare you move
 to catch *Etwie's* cub
 With the intent of hiding it
 under a bushel?

WOAFA ME NWAW

Go to *Agogo* and *Begoro* and ask
About The vitamins and minerals
In my soft and boneless flesh.
The slippery, sticky fluid in my body,
And the *Ahɔɔden Mensa*
In my hard shell
Are thrown away only by the ignorant!

The horns on my head are my eyes.
If you examine my mouth,
There're no teeth;
By the time I crawl to the stage,
The game is over.
How can I scream if I have no neck,?
Where are the wings for singing
"Pata Pata"?
You've grabbed me effortlessly
'cause I am an *Otope*.
Keep hitting me *tɔɔ tɔɔ*!

ƆDEHYE NSU

(17) ROYALS DON'T CRY
(ƆDEHYE NSU)

1. The problem you had
Cut you painfully to the stomach.
If you narrate it to others
No one understands it
or is able to help.
Do brave yourself and face it squarely,
Because the royals don't cry.

2. No one knows you became
Saddled with debt,
That strapped you by the neck.
You have neither
A benevolent uncle nor aunt
And there is no mediator.
So make sacrifices
And pay them off
Because the royals don't cry.

3. If you are accused of ill-speaking
And forced to remain silent,
Go live on *Kawaanopaado* Street.
Keep quiet while the witnesses speak.
Don't even cough
For someone to hear you.
Because the royals don't cry.

ODEHYE NSU

4. Debt, toothache and stomachache,
 You keep them to yourself
 when they attack.
 They aren't visible for others to see.
 But when the storms arise
 And the waves roar
 And your sun disappears at noon,
 Son of the Creator, don't cry.

5. However, if some loved ones depart
 And there is no one to comfort,
 If your heart is burdened with sorrow
 And there is nothing you can do,
 Don't bottle it in and get sick.
 Disciple of Jesus,
 you should at times cry.

 6. Stop crying after a while.
 Wipe your face and attend to others.
 Because Mary and Martha
 Look up to you
 And everybody else is watching you.
 Let Lazarus get out of the grave
 Because royals don't cry too much.

MƐKO NYINAA MMO MU MMERE

(18) PEPPERS DON'T ALL RIPEN AT THE SAME TIME
(MƐKO NYINAA MMƆ MU MMERE)

1. *Nkyerema* will grow if well planted
 But *Ntonko* does well
 even on the dug hill.
 Apetupre (the song bird)
 helps multiply *nyera*
 And *Kpapko shitɔ* commends kenkey.

2. *Ogyengua* (the sweet pepper)
 enriches any flat broth.
 Akwele's fingers point skywards.
 Pepper is the chief of all condiments
 So never be without some.

3. Ripe *Nyeraa* (tiny peppers)
 are what the birds like.
 But if your blackness causes
 The pestle to insult and degrade you,
 Remember, peppers don't
 all ripen at the same time.

4. Some of life's riches
 come in the morning,
 But others come in the evening.
 If yours have been unduly delayed,
 Remember, peppers don't all ripen
 at the same time.

NKYƐMFERƐ

(19) THE SHEILD
(NKYƐMFERƐ)

1. *Dekyɛm* is the arrow bearer,
So when clubs and guns assail us
And there is no helper in sight
We cry out for *Mr. Dekyɛm.*

2. He comes quickly and stands up.
He raises his shield
against the weapons,
So pain and cruel death pass us by,
While under *Mr. Dekyɛm's* protection.

3. If the right hand wields the sword
And the left holds the armour,
One fights to destroy the enemy,
While the other protects us
from the stones and clubs.

NKYƐMFERƐ

4. A shield fashioned from wood
 And strengthened with metal,
 Protects your head from injury
 From all the weapons of the enemy.

5. We shall not wait
 for the clouds to gather
 And cover the face of our sun.
 Before we shout and scream
 To call our Armour and Shield.

6. Every odd day is good for prayers.
 We go into our bedrooms
 And shut the doors.
 We kneel down on the floor
 And ask for protection
 from our Amour.

AKOFENA

(20) THE MIGHTY SWORD
(AKOFENA)

1. From where did the enemy come
 To sneak in on us so quietly?
 Where will we stand to face them
In order to protect family and property?

2. We have no stones or guns or lances,
 And yet we must face them squarely.
 Whatever we have helps protect us,
 And we fight to vanquish the enemy.

3. We bow down on our knees,
 Or gaze into the blue sky.
The faith we have that Papa overcomes,
 There is no weapon above this.

AKOFENA

4. So strengthen your heart
 And let us cry out in ardent faith.
Be courageous and lift up your sword.
 Let's always overcome the enemy.

5. Lift up your sword!
Swear to Nana and the community,
 That you'll always be faithful,
 And also protect them.

6. Touch the shoulders of your helpers
 With the old mighty sword.
 Honour then encourage them,
For standing with you at all times.

NYANKONTƆN

(21) THE RAINBOW
(NYANKONTƆN)

1. The rain clouds darkened the sky.
 We feared the rain
 would destroy everything.
We covered the cocoa beans on the mats,
 And quickly removed the laundry
 from the line.

2. But the sun came up suddenly
 And shattered the clouds with light.
The light that destroyed the darkness
 Was like an arch
 that touches the ground.

3. Red that is mingled with gold
 And blue that is edged with green.
 When did *Ananse Akuamoa*
 Go up into the sky
To weave this very colourful yarn?

4. Humanity overstepped its limit
 Into destruction.
After the flood Father had compassion.
The rainbow is a sign of his promise:
 Everlasting love says,
 No more destructive floods.

EMO

(22) THE MIGHTY RICE
(ƐMO)

1. Little grain that feeds millions,
You are related to wheat and millet,
But you require lots and lots of water.
That is why you do well
Even in mashes.

2. You drink and grow up hurriedly
And produce millions of seeds on stalks.
The wind blows and they grow,
They wave until the harvest time.

3. Spread the harvest in the sun.
Let them dry
To make it easy to weanow.
Pound it in a mortar
Until the entire husk is separated.

4. Cooking rice also demands water.
Ricewater requires milk and sugar.
Ɛmotuo (Riceballs) invite
groundnut or palm-nut soup.
Layemli (Hot rice and stew), and *jolof*,
The kind lovers always remember.

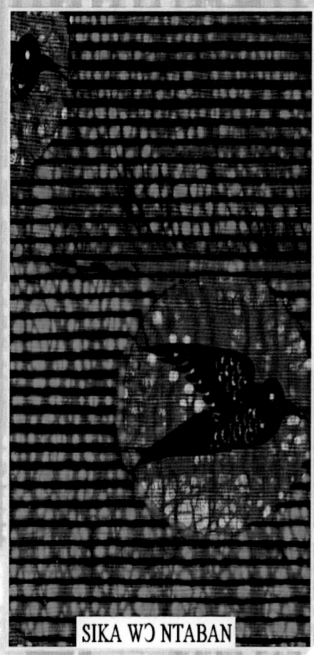

SIKA WƆ NTABAN

(23) MONEY HAS WINGS
(*SIKA WƆ NTABAN*)

1. Whatever job you undertake
Is likely to put something in your hand.
If you turn it over
and take good care of it,
It will multiply
and give you joy and power.

2. That power builds you a house,
Or buys you land for farming.
You could even travel to China
To buy lots of things to sell to others.

3. When something comes
into your hands,
Be benevolent and pay your taxes.
Be humble and serve your country.
Always remember
that money has wings.

4. It may be gold or silver
(red or white) Currency notes,
nuggets or powder.
Put a stone on it, save it properly,
Winged money flies away very fast.

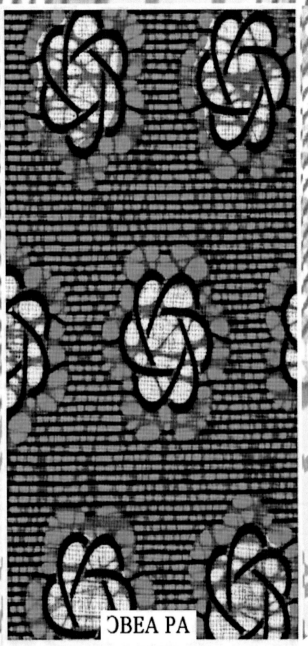

OBEA PA

(24) THE GOOD WOMAN
(ƆBEA PA)

1. The beautifully printed cloth,
 Presented me by my sweetheart
 Was quite unlike anything
 I had ever seen before.
 "By what name is it called" I asked,
 And he said, THE GOOD WOMAN.

2. It was very sunny
 In a particular year.
 The severity of the heat was unusual.
 Trees shed their green leaves,
 And flowers all withered.
 The umbrella that gave me shelter
 Is called THE GOOD WOMAN.

3. It thundered mightily one day.
 As lightning flashed constantly,
 The dark clouds frightened us.
 It rained heavily for days and days.
 The good arms that sheltered me
 Are called THE GOOD WOMAN.

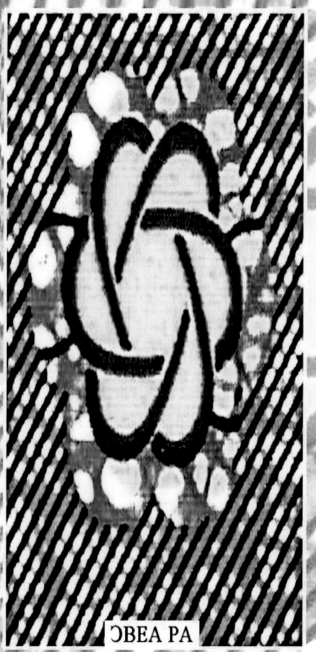

ƆBEA PA

4. We are very grateful to the creator
 For our mothers and loved ones too.
 He uses them to bless us abundantly.
 Good training and, "Stop that Kwasi!"
 The Good mother
 who has Many children
 Is certainly THE GOOD WOMAN.

5. The good woman loves you dearly
 And feels your pain and hurt.
 The shade in the noon time heat,
 And the warmth of the winter cold.
 Turn your eyes to someone near you
 And tell her GOOD WOMAN.

6. The hardworking good woman
 Changes things and makes them better.
 She exudes hope for everyone.
 She cares for the poor and the orphans.
 They prosper and say with gratitude
 ADWOA IS A GOOD WOMAN!

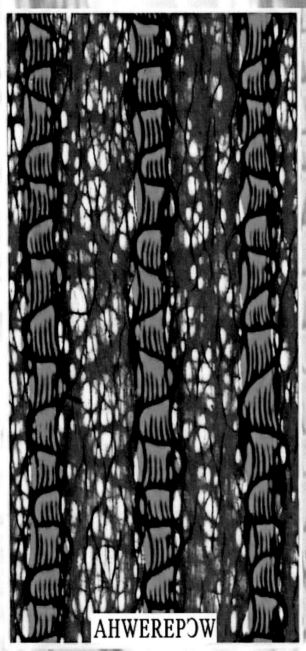

AHWEREPƆW

(25) SUGAR-CANE NODES
(AHWEREPƆW)

1. From where did sugar-cane nodes
 get to Jamaica?
And from where did it get its sweetness?
 It grows near rivers and also in mashes.
 How come it is sweeter than rice,
 Which also grows near
 The river at *Asutware*?

2. The nodes divide the cane
 Into segments
 Of about one foot from another.
 The node area
 Is a little harder than the cane,
So we don't chew it with the cane
Because it has no fun or sweetness.

3. The node is however very important,
 That's where the eye of the cane is.
 If you plant it in the ground,
 That is where the roots develop.
 They shoot into the soil
 To grow the cane.

AHWEREPƆW

4.	The frond of the sugarcane
is not chewable
And the node is too hard to chew.
We remember to cut the cane
between nodes,
In order that we may plant the nodes.
Without the nodes,
there will be no sugar.

5.	We produce sugar from the cane.
Slaves and maids work on large farms.
They plant the cane and help it grow.
After the harvest
comes the press for juice.
Boil the cane juice till it is sticky.

6.	Refine the sugar till it's white.
Pack it in bags ready for the market.
Sugar sweetens the porridge.
It can also be used
to produce honey and rum.
The uses of the sugarcane nodes
are many.

OBO NKWANTIA

(26) THE OUTSKIRTS OF OBO
(*OBO NKWANTIA*)

1. What often happens in many places
 Is that the avenues are in city centers,
 Where palaces and banks exist,
 With parks and plazas
 and meeting grounds.
 We plant them deep
 In the heart of the city.

2. The latecomers who arrive later
 From places we do not know,
 Are the ones who create shanties
 And roof them with grass,
 To show us that they have just arrived.

3. So when enemy forces attack,
 Intending to destroy the city,
 They start from the outskirts noisily,
 Looting things and torching houses
 Before they move towards midtown.

36

OBO NKWANTIA

4. There aren't any wars these days,
 So we aren't scared of our enemies.
 But the population has increased
 And caused our cities to expand.
 The outskirts are no longer messy.

5. Travellers who go abroad
 To sweat and labour exceedingly,
 Are the ones who settle on the outskirts.
 They fell trees and build houses
 To display what they have seen in Accra.

6. The outskirts of *Obo* is spectacular.
 Buildings that are intricately designed
 Are surrounded with bright lights.
 There are gardens filled
 with beautiful flowers.
 That is where *Aframea*, my love lives.

NKATEHONO

(27) PEANUT (GROUNDNUT) SHELLS
(NKATEHONO)

1. Mr. Carver's timely advice
Made Alabama farmers plant peanuts,
 To replace the cotton
 destroyed by weevils;
 Though no one ever wore
 peanut clothes.

2. They boiled and roasted some
 for food
And then attacked Carver angrily.
They probably would have killed him,
Because no one would buy peanuts.

3. They did not raise AMOAKUA
 (ground squirrels)
 To whom they could entrust
 their peanut farms.
Carver researched and meditated
 for sometime
 To invent three hundred
 peanut projects.

NKATEHONO

4. Butter, cheese and milk
And oil for both cooking and rubbing.
One hundred and thirty-nine products
So if you are allergic to one,
You try another.

5. Peanuts enrich the soil.
After you plant and harvest it,
Whatever you plant in its place
Grows up wonderfully.

6. Peanut leaves are quite medicinal.
You can mix the husk
In pig and animal feed.
You can also weave it into a good mat,
On which you can sleep deeply.

OWU ANTWERI

(28) DEATH'S LADDER
(OWU ANTWERI)

1. There are seats for the elderly,
Quite different from the ones for kids.
Yet the elders who've lived long lives,
 And the babies who
 are still learning to sit,
Ɔdomankoma Owuo takes them all.

2. The rich
 Have big and beautiful homes,
 But the poor sleep in tight corners.
They take their bath in the open street
 And wrap their stool in plastic bags.
 All-encompassing Death
 Knocks at all doors.

3. The wise
 Learn to exercise their minds,
While the ignorant dance in the sand.
 They claim
 They don't know what's happening.
 They are content
 With their low standard.
 Unfortunately,
 Death steals them all away.

OWU ANTWERI

4. Death, Old Thief
Who destroys homes,
All-encompassing, yoke of mankind.
The wrecker who snatches us from life,
When he puts up his crooked ladder,
Death's ladder is a universal climb.

5. He started troubling us
A long time ago.
He shortened Grandpa Adam's life
And took Methuselah away too.
Do those of us
Who are Father's neighbors
Have to flee
When we hear Him coming?

6. Fact is we will all die
And not turn into stones.
When Death took Adam,
He took his Son also.
The First Born was entombed
For three long days,
But His resurrection teaches us that
We climb Death's ladder into Heaven.

KWAME NKRUMAH PENSRE

(29) KWAME NKRUMAH'S PENCIL
(KWAME NKRUMAH PENSRE)

1. Osagyefo was such a good speaker,
 The whole world admired him.
 Even his enemies
 Remember his speeches.
 Kwame's mighty words
 Removed great trees.

2. But before he gave any speech
 He would sit and think it out carefully,
 Before he wrote it down on paper.
 Nkrumah's pencil was very sharp.

3. Unlike the stubby ones you and I use,
 For which we always need
 A machete for sharpening,
 Before the blunt lead appears,
 To enable us write something.

4. Kwame Nkrumah's wonderful pencil,
 That was his very mighty sword
 With which he fought everywhere.
 You must use yours effectively.

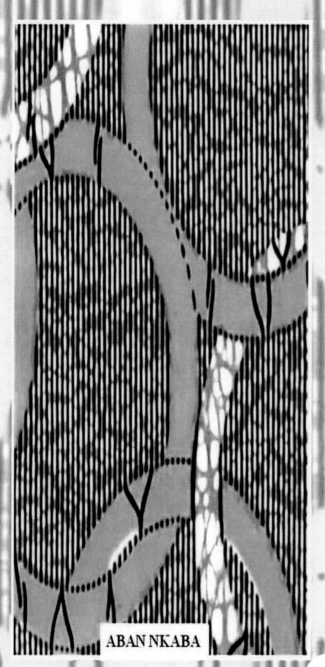

ABAN NKABA

(30) THE RINGS OF THE LAW
(ABAN NKABA)

1. When Kofi likes Afua,
He falls head over heels in love.
He worships, pleases and praises her,
Until their relationship is solid.

2. There is the courting
And the engagement,
After which
The lovers exchange rings.
Their wedding brings
Joy to the families,
They delight in their friends' marriage.

3. The government is for all of us,
Whether we vote for it happily,
Or angrily vote against it.
The winning government is for us all.

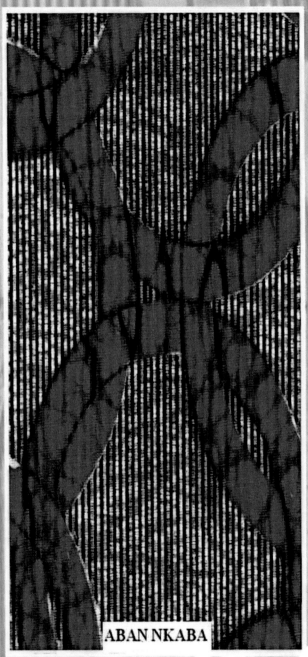

ABAN NKABA

4. If he is good to us all the time
And makes us safe and happy,
He should never
Put a ring on our fingers,
Nor a bracelet on our wrists.

5. The laws' bracelet with a key to it,
The police are the usual officiators.
They put your hands
In front or behind you.
They secure the cuffs
And keep the key.

6. If there are more lovers of the law,
Than there are bracelets
For all of them,
He pairs them up for a set of bracelets,
To display the extent
Of love he has for them.

7. The shinny beautiful wedding ring
Makes family and friends
Congratulate you.
But if you allow the law
To put rings on you
It is a sign that the home is broken.

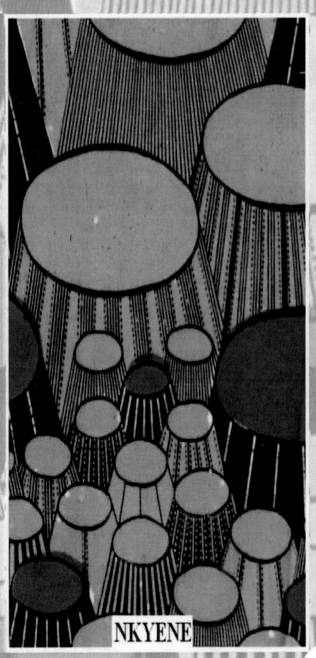

NKYENE

(31) DRUMS
(NKYENE)

1. Drums differ,
Big ones and small ones.
Carved out of wood
And covered with hide.
Because it is hollow inside,
Produces a good sound when beaten.

2. The small drum with a high note
Is a female with a resounding voice.
The big low sounding one is a male,
Play them together
For pleasant music.

3. We beat the drum when
There's an emergency.
It summons the people
To the chief's palace.
The urgent message
of the emergency drum,
Should never be ignored.

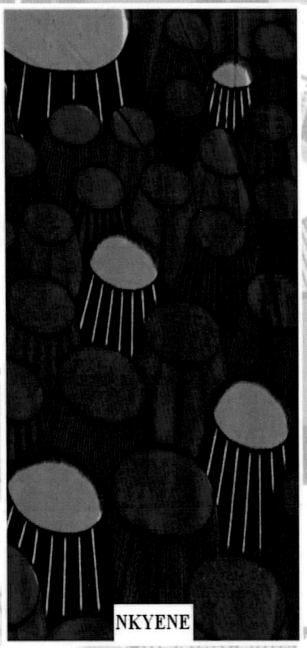

NKYENE

4. Play merry tunes on the drums
For the young men and women
To take the floor.
By their steps and lively twirls,
They show how well
They understand drum music.

5. Don't mistake the side of the drum
For the top.
If you have a grudge against someone,
Talk it out.
Rather than harbor it in
And misbehave towards them.

6. When there is a serious emergency
And the big *(Fͻntͻmfrͻm)* drums
Are talking,
Royalty wears red cloth
And chews cola nuts.
They offer sympathy
And condolences to the people.

AFOFANTƆ

(32)　　BUTTERFLY
(AFOFANTƆ)

1.　　　The tiny eggs I saw
On the broad green leaves,
Hatched a few days
Into millions of larva.

2.　　　They started devouring
The big leaves,
And destroyed the tree completely.
Though birds preyed
Mercilessly on them,
The rest bravely protected themselves.

3.　　　They wove
Protective clothes for themselves.
The pupa eats no more but breathes,
Until it hatches from its sack.
It moves very, very, slowly.

4.　　　After about an hour,
The beautiful maiden
Stretches her wings
And then flaps them again boastfully,
Before flying to a nearby flower.

AFOFANTƆ

5. She strengthens herself
By sucking the nectar,
Then flies to another nearby farm,
To greet the farmer who works there,
And to ask him
How she may serve him.

6. After about a forthnight,
I rode in a vehicle
From Dome to Mpraeso,
Upon reaching the peanut farm there,
I saw the Butterfly
Hopping from place to place.

7. "Butterfly, how did you get here?"
"I flew in the wind" she says,
"So even if you fly in an airplane,
I will meet you in a vineyard
in France."

8. A little insect
Who doesn't have a thigh,
The farmers' hip-hopping friend,
Who helps flowering plants
To bear fruits,
Clap your hands, for you're beautiful.

WOREKƆ AWARE A, BISA

(33) RESEARCH BEFORE YOU COMMIT
(WOREKƆ AWARE A, BISA)

1. He who asks for direction
 Doesn't miss the way,
 Even though there are
 Many junctions and turns.
 Because there are twists
 And turns in marriage,
 Research before you commit.

2. When we marry,
 We join another family.
 One family is different from another,
 And there is a secret in every family,
 So research before you commit.

3. We'll stand by you in difficult times.
 If it happens
 In the community or one nearby,
 Mom and Dad will go for you,
 So research before you commit.

4. If you need to travel to a distant place,
 A brother or a sister will accompany you.
 But since
 There's the need for preparation,
 Research before you commit.

WOREKƆ AWARE A, BISA

5. He who asks, obtains direction.
He learns the traditions
Of another land.
If you would like to do things perfectly,
Research before you commit.

6. All that glitters is not as good as gold,
But we are all looking for the best.
If you would like to join hands correctly,
Research before you commit.

7. If you don't ask, nobody will tell you,
You wouldn't know without researching.
Because we hide a lot under our clothes,
Research before you commit.

8. You'll research before you start.
He/She will inquire before committing.
Some problems,
seem to have no answers,
So inquire from Daddy
Before you commit.

ADWOKU

(34) THE FISH TRAP
(ADWOKU)

1. We drain the pond for delicious fish,
But because we are partial
To the mudfish,
We can't bail out all the water
In River Volta.
We'll cast nets instead
For a bumper catch.

2. If you want to catch one loosely fish
To compliment your meal of kenkey,
You will attach a hook to a pole or rod,
And use a worm as bait.

3. Because you'll need more fish later,
In about a week, look for palm branches,
Weave them into traps with one opening,
Making it impossible
For its entrants to get out.

4. Fill it with palm nuts and some fruits.
Set your trap somewhere in the deep.
The crafty fish will go in to feed,
And wait for you when they are full.

NSOROMA

(35) THE STAR
(NSOROMA)

1. We see our way clearly
When the sun shines.
We do not prod around blindly.
The sunshine opens our eyes,
Enabling us to see where we are going.

2. When it is dark and the night comes,
We don't see our way clearly.
We miss our way
To places we usually go,
We pass them by and get lost.

3. When the sky darkens,
And we are in need of good direction
A star shines out of the darkness,
And helps us get to our destination.

NSOROMA

4. Some big stars shine brightly.
There's also the devoted "*Kye Kye*"
Always attached to the moon
For a loving relationship that shines.

5. The star is a very good guide.
It guides the Wiseman from the east,
Even if Herold is ignorant
Of what has happened.
It leads them
To the birthplace of the Child.

6. There's a Red star
As well as a Black one.
When everything is bright,
Blinding and hurting our eyes
With unfriendly glare,
The Star of Ghana leads us on slowly.

ANIWA

(36) THE EYES
(ANIWA)

1. Two wonderful windows
 Placed in front of a mountain,
They shut themselves when it's dark,
But open up to receive light for work.

2. A black pupil with a mirror in it,
 And is surrounded with a white.
The eyebrows on the ridge of the eye,
Prevents sweat from entering the eye.

3. But there are also the eyelashes,
 Who act like the lock on a window.
They click open and then shut again,
 To protect the eye
 From dirt and enemies.

4. These two windows shoot pictures,
 And transfer what they have seen,
 To the brain hiding in its chamber,
 Who quickly translates the image.

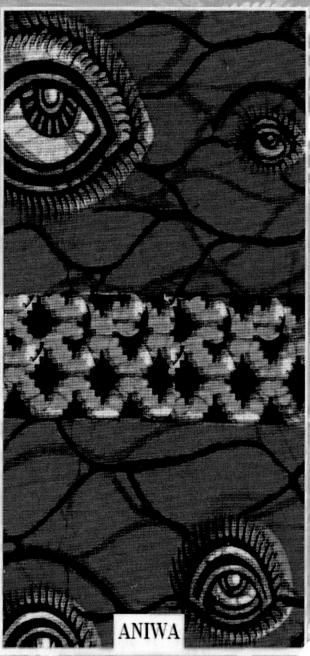

ANIWA

5. If something is attractive or dirty,
If it looks good enough
For us to pursue it,
We think about what we should do.
The window of the eye is a blessing.

6. If you don't see it,
You cannot admire it.
So when the mirror gets fuzzy,
The well that's situated in the eye
Helps us wash it clean again.

7. If our hearts are filled with grief,
Making them heavy and overburdened,
The heart and the mind force the eye
To pump out a lot of water
from the hidden well.

8. When that happens, the eye reddens,
But when the body gets tired,
The eye that doesn't know sorrow,
Shuts its windows instantly.

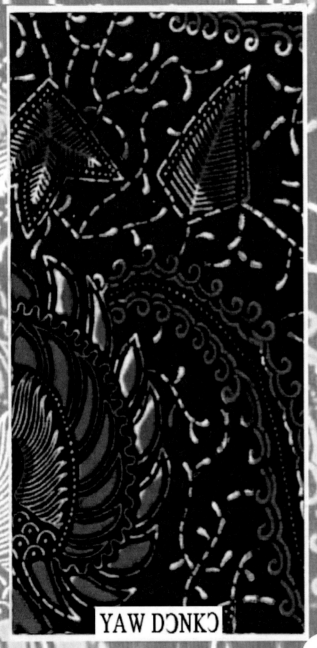

YAW DƆNKƆ

(37) MR. YAW DƆNKƆ
(YAW DƆNKƆ)

1. My mum told me that
She got married
During her adolescence,
And she was very happy ,
Because my father
Was an up-and-doing man.
A man who was handsome.
They strained every nerve of theirs
To work,
And made their farm crops
Objects of tourist visits!

2. But the sorrowful news is that,
When my mother conceived
And bore her first child,
A beautiful boy
Who resembled his father,
And his nose was slim and shapely,
Yet he did not survive long.
For just as he learnt to sit,
And began to crawl,
He was whisked away
by never dying Death.
From the hands of father and mother.

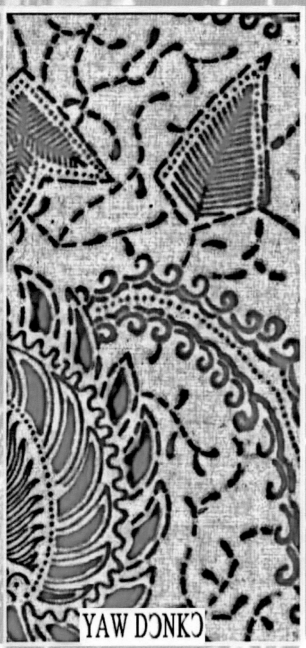

YAW DONKO

3. Relations forced the couple
To stop weeping,
And comforted them
With the words that
The creator will bless them again,
And make good their loss soon.
And truly,
it was not even three months
When mother
Was seen to have changed.
So by the next year
She was carrying a beautiful girl
At her back.

4. Manubea,
was as beautiful as a string if beads,
And the hair on her head was bushy.
Mother took good care of her
And father too
Virtually worshipped her daily.
So she sat, crawled and walked.
Because of her prattle and adult ways
Mother forgot her pain completely
Until Manubea got four years.

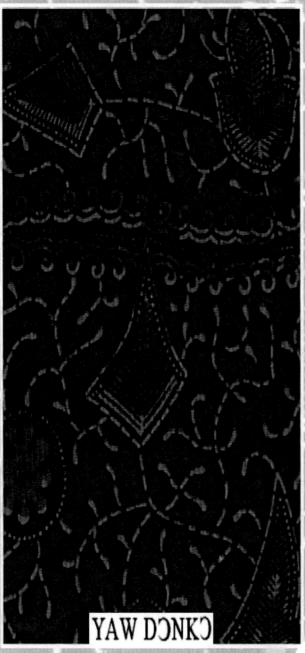

YAW DƆNKƆ

5. No one knows
From where death came,
To visit with Kwaku and Akua again,
And destroy their happiness completely.
When Manubia left them,
The house became quiet again.
For this reason,
When mama conceived again
And delivered the following year,
everyone was full of concern .

6. Out of the concern,
Serrations were made on my cheeks.
And I was named *Yaw Dɔnkɔ*
(Thursday born slave)
To prevent me from being heady
And leaving them once again.
Because I was made a slave
I did not enjoy myself.
I was taken to stay with people,
So as to make the hardening
From serving,
Ground me firmly,
that I may remain long here.

YAW DƆNKƆ

7. Because I stayed for long
Father and mother had six children.
My main focus was farming,
So I set out at dawn every day.
Water on leaves
And the dew didn't bother me,
I made the joy in farming
Help me and my parents every day.
Because of this there are many friends.

8. Yaw Dɔnkɔ, nobody's slave
To be suppressed and exploited daily,
Before he does what is right.
Energetic and helpful as he is,
He is a good model to his siblings.
Because he is independent,
he gives them good foundation.
And teaches them daily
the right things to do.
Yaw Dɔnkɔ is a true son of the land,
And the community.

ABUROW NE NKATE

(38) MAIZE AND GROUNDNUTS
(*ABUROW NE NKATE*)

1. Perhaps they aren't
 Related in any way,
 Maize grows its cobs
 On the sides of a plant,
 While groundnut grows in shells,
 One is up in the air,
 The other is underground.

2. It is time we sow both of them
 In the soil and cover them up,
 Maize hurriedly shoots up,
 Growing taller
 Than the one who planted it.

3. The groundnut acts patiently,
 It lies and plays in the ground,
 Its roots develop little knots,
 That grow into nuts under the ground.

4. Grown maize is dried.
 And mature groundnuts are
 Uprooted, dried and shelled.
 Either boil or roast
 And then mix them together,
 Maize and groundnuts,
 Stop hunger number two.

OBO FA DADE FA

(39) PARTLY ROCK, PARTLY IRON
(ƆBO FA DADE FA)

1. There is hope in every situation
From the dark rain clouds
Come lightning flashes,
And after the run of daylight
There will be darkness,
So at any juncture you find yourself,
Don't grow weary, don't be discouraged.
If a part is rock, another part will be iron.

2. By the rock's resilliance
Iron is sharpened.
Iron is strong and gives a good base.
If you want your tower to stand so firm,
That no rainstorm may frighten you,
Then mix rock chips and iron
In the cement mortar
That your foundation may be good.

3. Bitterness and sweetness,
Hot hot pepper and grilled salted tilapia,
Cold *nkamfo* chips, or hot *kenkey*,
Boiled rice served with hot stew,
With cold ice cream
That sets the teeth on edge,
The sorrows of a fall,
And the joy of rising up-
Life is partly rock, partly iron.

MFURA ME KUNTUNKUNI

(40) NO MOURNING CLOTHES
FOR ME
(MFURA ME KUNTUNKUNI)

1. Put on no dark mourning clothes
 (*kuntunkuni*) for me.
Do not wear a red head band (*koogyan*)
 Reden not your lips with cola
 And don't take off your shoes
 For my sake.
 Don't bare your chest,
 Cry not nor let your nose run,
 While you mournfully lament:
 "I am finished" "I am finished"
 With whom did you leave me.

2. Send me greetings while I am alive.
 Turn your eyes and look at me.
 Delight in my happiness,
 And mix your tears in mine,
 Mourn with me.
 Send me condolences and sympathy,
 While you and I are alive.
 Do not wait for me to die
 And close my eyes,
 Before wearing dark
 Mourning clothes for my sake.

HUHU-HUHU NYƐ ME HU

(41) LOUD BOASTS DON'T FRIGHTEN ME
(HUHU-HUHU NYƐ ME HU)

1. I have shut my mouth
And I am quiet,
While you roar and shout like a lion.
Because you are Goliath the giant,
You have silenced king Saul
Just like a child.
I only need five clean pebbles,
Because loud boasts don't scare me.

2. You have closed the market at noon,
And destroyed
All the plans of the traders.
You boast that your finger
Is bigger than your dad's thigh.
You will rant and snort
And destroy everything.
Odiatuo the courageous
King of Peace's message Is that,
Loud boasts don't scare me.

63

HUHU-HUHU NYƐ ME HU

3. Like Jehu you have been anointed
To destroy Jezebel and all her clan.
If you forgetfully exceed your limit,
And parade yourself arrogantly,
Your cruelty and bloodletting
Doesn't frighten me.
We parted ways a long time ago
So loud boasts don't scare me.

4. The changes in time
Glorify the Father.
So if your destructive era is gone,
And the tears of loved ones
Are dried up,
Don't hide behind Kabute
And frighten me.
We parted ways a long time ago
So loud boasts don't scare me.

AKUFO'S AHENNI

(42) AKUFO'S REIGN
(AKUFO'S AHENNI)

1. Saul was the first king of Isreal.
 He wished one of his children
 Would succeed him.
 But David the shepherd boy
 Who sang and played sweet music,
 Was the one God ordered
 Samuel to anoint.
 He was a man after God's own heart,
 Who made many mistakes
 And then repented.
 The lord who loved him corrected him
 And set him on a broad highway again.

2. Kwasi Akufo reigned at Akropong.
 Peace, brotherly love,
 And good governance
 Made Akwapim famous and prosperous.
 Because he was just and truthful,
 His people carried him high
 During Odwira festivals.
 Plentiful harvests and the prosperity
 Enjoyed by all,
 Made the people respect him greatly.
 Speak eloquently and offer good advice.
 Wear humility like a splendid new cloth
 And name it Akufo's reign.

AKOSOMBO AKANEA

(43) AKOSOMBO LIGHTS
(*AKOSOMBO AKANEA*)

1. There are big bright lights
And small ones too.
Flickering ones
With rags serving as wick.
Heavenly stars, the moon and the sun,
They give power, light,
Fire and strength.

2. The gas-light under which
We sell *kelewele,*
And the traficator that indicates
Where you are turning,
It blinks and blinks repeatedly,
To tell you which way
Driver Yaw wants to turn.

3. The indicator is often small,
But reminds you that the water
Or the oil is running low.
There is also the torch that blinks,
Warning you
Of the fire on the mountain.

AKOSOMBO AKANEA

4. Hydroelectricity provides light,
It makes heavy machines turn.
It is better than kerosene
Or palm-kernel oil,
Or better than any flaming torch.

5. Power for the nation of Ghana
Comes from Akosombo.
The mighty Volta Lake
Gives us hydro-electric power.
We use it for many things,
even for cooking.

6. The giant who makes
Accra beautiful,
And makes Larteh
a light on the mountain.
The light from Akosombo is wonderful,
So may we never extinguish it.

KRAMO NTE HAUSA

(44) THE IMMAM DOESN'T UNDERSTAND HAUSA (*KRAMO NTE HAUSA?*)

1. If you are an Akan
Who doesn't understand Ga,
And you lose your way at Ako Adjei,
You ask someone on the street for directions.
The best answer he gives you is "mmm".
With raised shoulders and a finger in the ear,
He says something you don't understand,
Emphasizing
I don't get it, I don't understand Twi.

2. If you would like to be a Basel minister,
(Presbyterian)
They will advise you to go to Trinity College.
Learn how to preach, be humble and clean.
Speak Hebrew as well as Greek.
Pray as loudly as Saul's brother Paul,
Liken your preaching
To that of fisherman Peter.
It doesn't matter
If you don't know how to dance.

3. We notice you wearing
A long flowing gown.
Your beard is white and elegant.
You face the direction of Koforidua and kneel.
You touch the ground with your forehead
And then rise.
You mumble some words we don't understand.
The Immam has visited Mecca in Saudi Arabia
And returned,
But doesn't understand Hausa?

68

OBEATAN

(45) THE MOTHER
(ɔBEATAN)

1. Stir the pot carefully,
Let the thick sauce at the bottom
Blend nicely with the oil at the top.
Dish out Dad's
And add chunks of meat.
Serve Aunt Akua
And Uncle Papa Kofi also.
But leave two shrimp
And the clams
That are stuck at the bottom.
The good mother
Knows how to feed her child.

2. The hard surface of the rice is all gone.
The visitors have eaten all of it
Before leaving.
The dog grunts hoo-hoo, ham–ham.
The cat protects its meat
With its powerful left paw.
If the "take aways"
Have emptied the pots,
Leaving only the burnt rice, chicken legs,
And chicken heads, don't be surprised.
Just say life is good;
Mother knows how to feed her child.

OBEATAN

3. Mighty Eagle who lives in the clouds
In your soft comfortable nest,
Great hunter
Who swoops down from the sky
To catch good things
To share with your children,
If the eaglets don't learn to fly and hunt
Because they enjoy living
In the luxury upstairs,
When the water in the Volta dries up,
Does Nana know
What to feed his children?

4. Mr. Kwasi *Menkomeyam*
And his wife *Adiamawoba*,
He puts his hand in the bowl
And fills his mouth.
The other also overeats
To the point of vomiting.
Devour parcels meant for others,
Grab what's for absentees,
The national treasury empty,
Family lands cheap.
When this sunshine ends and the sun sets,
Mother, do you know
What your children will eat?

KATA WODEƐ SO

(46) COVER-UP YOUR OWN
(KATA WODEƐ SO)

1. The fresh hot kenkey
Doesn't stay long at the market.
The people buy it hurriedly.
They add the pepper and fried fish,
To stem their hunger
And satisfy themselves.
So if I am away and things are bad
And I have left my *apakyi* gourd with you,
It is not your fault by any means.
Friend, cover-up your own
And expose mine to the weather.

2. We talk about the person in the news.
We say and say and broadcast with a bell,
Slandering, conniving and maligning
These do not befit you as an Akan,
I belong to no clan and I have no family.
Nobody will struggle to save me.
Neither do I have a say in the community.
If you are making good sales this Tuesday,
Expose my little balls of kenkey
So they get cold
While you cover up your very big ones.

TOWN HALL

(47) TOWN HALL

1. Every town has its streets.
Narrow ones
And broad ones that intersect.
At the center there is a park,
And the Town Hall
Is an important place.

2. Children play in the park,
They run, hop, step and jump
And forget the cares of the day.
The Town Hall is a happy place.

3. Adults labor
And perform many tasks,
They summersault
Searching for what to eat.
At dusk they wear their Kente cloth
And go to dance at the Town Hall.

TOWN HALL

4. Coming from Tinkong,
 you wouldn't understand.
There you do everything on the street.
 There you go to the chapel
 For thanksgiving.
There is no town hall anywhere.

5. Kumasi and Cape Coast
 Are good examples.
 Top meetings discuss
 The welfare of the country,
And honour distinguished people too.
All take place at the Town Hall.

6. If you're really in love with me,
And would like us to journey together,
 Sharing warmth in winter
 and comfort in the heat,
Sweetheart, meet me at the Town Hall.

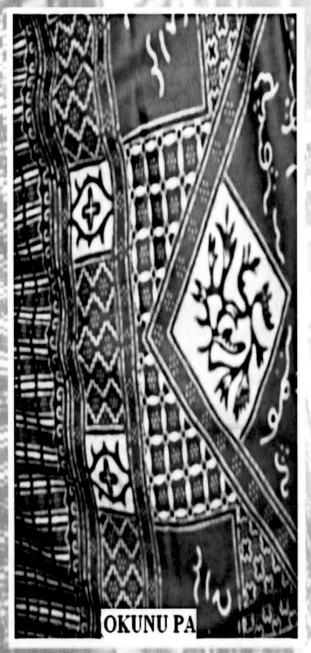

OKUNU PA

(48) THE GOOD HUSBAND
(*OKUNU PA*)

1. The good, brave young man,
He strains himself to work hard.
And when money comes into his hands,
He saves some towards an objective
He has set for himself.

2. He takes good care of things,
And is very discerning.
If he decides on one thing he pursues it,
Until he obtains it and holds on to it.
He plucks it
And places it on his veranda.

3. He buoys up his pleasure tree
Through conversation
And encouragement.
He always protects her and her children
And sees to it
that they don't lack anything.

4. The good husband is a real lover
On whom you can always rely.
If you commit anything to him
He keeps it very well
And makes it useful.

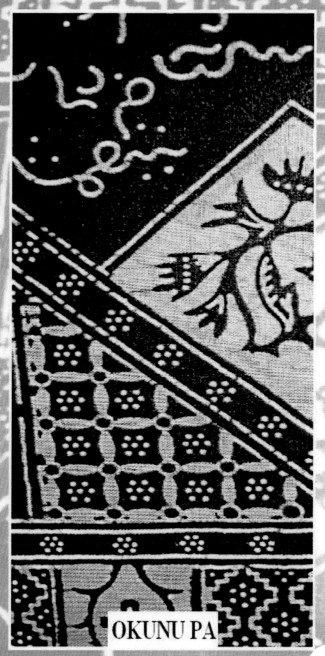

OKUNU PA

5. A merciful and gracious person
Who is slow to anger has boundless love.
When some one offends him,
He doesn't brood over it.
The good husband
Always has compassion.

6. A real helper who baby-sits,
Like an au pair for his children.
And from the farm
He always carries a heavy load,
To set an example for Yaw and Kofi.
The good husband
doesn't turn his wife into a maid servant.

7. A good supporter to lean on.
When he sees what requires doing,
he does it joyfully.
You can rely on him to do just that.
The good husband
will exceed expectation in this.

8. The good husband always listens
To his wife.
He draws her onto himself
And unites with her,
The comforter who wipes away tears,
Thank the Father
Regarding the good husband.

SAKRA WO SUBAN

(49) CHANGE YOUR CHARACTER
(*SAKRA WO SUBAN*)

1. In all that you do,
They talk against you.
For example if wherever you go
Disturbances arise
And misfortune results,
It is not because they hate you
Or that no one
Is interested in your well being.
So *Kwasi*, change your character.

2. If you possess
That which everybody desires,
And you are the be-all-end-all,
If in your absence
The game can't go on,
If you are the only saviour,
Who possesses the power
Of life and death
That moves the crowds,
Because time changes,
Nyantakyiwa change your character.

SAKRA WO SUBAN

3. If they ask for help from you,
But you never give any,
If they say "all hands on deck"
And you haven't got anytime to spare,
If you ever thought that
Those who contribute
Towards the common weal
Of the community do so
Because they are rich,
Ntiamoa the worldly wise,
Change your character.

4. Someone has pinched me,
I will pinch them back.
Another one has insulted me,
I will insult them in return.
If you cannot wait your turn,
And if you think those in the queue
Have no wisdom and that a short cut
Can make you go higher
than everyone else
Along the way you are going,
Then *Ananse Akuamoa*,
change your character.

SAKRA WO SUBAN

5. If your hands drip like sieve
 Such that all that comes to you
 gets lost,
 If you are as wicked as a bolder rock
 And no one's matter can sway you,
 And if because you are
 At the peak of your youth
 You don't know
 what your children will feed on ,
 But you keep prowling
 And sleeping everywhere ,
 Then *Cockerel Kwasi* ,
 Change your character.

6. If your strong shoulders
 Help you defeat all opponents,
 And because your loud mouth
 Drowns all others' music,
 Do remember that times change.
 Because someone stronger than you
 will come,
 And because the songbird
 invites pebbles,
 Akosua Ɔkyeraa ,
 change your character.

ƆBRA TE SE AHWEHWƐ

(50) LIFE IS LIKE A MIRROR
(ƆBRA TE SE AHWEHWƐ)

1. Dress up properly every morning.
Press your clothing before you wear it,
Tie your scarf and polish your face.
Yet before you step outside,
Ask the mirror on the wall
To show you your beauty.

2. It will point out the crumpled blouse
So that if necessary you may press it.
If your head kerchief is askew
You can then straighten the knot.
And if you look pale
You can oil your face.

3. A plain mirror without a backing
Does not give good images
And the one with a blurred surface
Does not reflect well.
If your mirror is large or small
Give it a good backing
And wipe the surface always.

ƆBRA TE SE AHWEHWƐ

4. A good life depends on
A good foundation.
So our parents raise and train us well,
Giving us faith that conquers the enemy.
The good support enables us go forward.
It shows us off for everybody to see
The stuff that we are made of.

5. Life is like a mirror.
So when you look back
You will see
the kind of life you have lived.
That which is straight and beautiful
Gives joy.
So to avoid the croocked and the ugly,
Seek repentance, quietness,
And a change of mind.

Life is like a beautiful mirror
Yet it is sharp, weightless and light.
Let the surface be clear
So that it doesn't become grissly.
Give it a faith base,
So that it can go forward,
Because when life
Drops from your hands,
Then the mirror is shattered completely.

KWADU SIAW

(51) A BUNCH OF BANANAS
(KWADU SIAW)

1. The plantain and the banana
Are cousins!
But there are differences between them.
Their stems and leaves
Resemble each other's.
So sometimes,
It is when they are in flower
That you can tell the differences.

2. Some people love
The plantain very much,
But they have no regard for the banana.
The advice of the elderly is
"Slash, burn, clear and sow your field.
Plant your plantains
And some bananas too."

3. The stout two-bunched type
From *Aperade*,
The seedless, *apantu* and *mpemma*.
Plantain demands
Fire, boiling and water,
Brokeman-roasting and frying in oil.
Flour is added- *ofam* and *apiti*.

KWADU SIAW

4. If storms fell all your plantain trees
But by grace your bananas withstand
And bear fruit,
Harvest it
And spread out the hands on a surface.
Until ultimately every green in them
Assumes a golden gab.

5. It doesn't matter when fires
In the house go dead.
The banana hand in poverty and famine
Can take you very far indeed.
Fried groundnut and a gourd of water
Is called "hunger killer number three".

6. When bananas become very soft
And their skin become spotted,
Smash a few of them
In flour and sugar.
Add some eggs and then bake it,
Banana cake will do you a lot of good.

AKOO YITSO

(52) A PARROT'S HEAD
(AKOO YITSO)

1. *Akoo Kofi* is a beautiful bird,
So if you get one of his feathers
And put it on your hat,
then you become a Guy,
For, it makes you share
In *Akoo*'s beauty.

2. *Akoo* is very brilliant in speech,
And he speaks English
Better than an Englishman,
So if you want to know
Public speaking very well,
Go to *Akoo Kofi* for lessons.

3. Those who finish studies at Legon,
Put on big Gowns and Caps.
Yet their Gowns and Caps
Do not match *Akoo Kofi*'s own.

AKOO YITSO

4. A broad forehead
And a flat backskull,
Two sharp seeing eyes
And a beak that curves like a hook,
Are together what the Ga people call
Akoo Yitso .

5. When *Akoo*
Is walking at the market place,
He lands, steps out
And turns here and there like a chief.
Yet because of his crooked claws
He can never
Put on the chief's sandals.

6. Parrots often flock together,
And converse
Amongst themselves always.
Yet when they are flying towards food
Akoo's Yitso help's it to arrive early.

ASETENA PA

(53) THE GOOD LIFE
(*ASETENA PA*)

1. When you are in bondage in Egypt
 And hard labor and suppression
 Make sweat fall all over your face,
 Then you need good living.

2. When you are living
 On your own land
 Yet you have no say
 In your country's governance,
 You've replaced your own language
 With someone else's,
 Then you need good living.

3. If all your churches
 Have been demolished,
 And your religion has come to an end
 Resulting in the absence of all hope,
 Then you need good living.

4. If you live in a golden realm
 And are surrounded
 By deep-green leaves
 Yet you are begging hand-in-palm
 That is no good living.

ASETENA PA

5. If all fighting
And troubles have ended
And where you will sleep
And what you will eat
Do not cause you any worry,
Then you are in the process
Of getting good living.

6. But do not let the joy of *Bugyanbura*
And the ease of life
In somebody else's Nation,
Make you forget
Where you come from.
And do not struggle
For good living in LA.

7. When you look up to heaven
And you reach out to your brother,
You move forward led by the cross
And that leads to good living.

8. If it is well with you today
And you have all that you need,
Do not let living on a white stool
Ever make you forget.

ME NSO MƐKɔ BI

(54) I'LL ALSO STEP OUT
(ME NSO MƐKɔ BI)

1. Someone called you
On the phone this afternoon.
You and that person spoke very softly.
It made your face change a little,
Then you said
You have to return to work.
If you haven't finished that work yet
Then go,
Yet remember that I will also go.

2. There are no children
That I might nurture,
And your Mother
Might think I am infertile.
Yet maybe it is you who needs help,
If you think its I who am in need
And that there is nothing I can do,
Then go, and remember that I will also go.

3. There is only one car that you drive,
In your absence I can do nothing.
I have gone shopping
So I will do the cooking,
While you play draughts for enjoyment.
If after that, you would go for a roll call,
Go, but remember that I will also go.

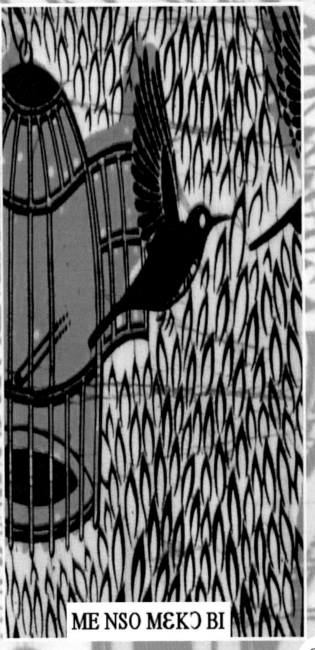

ME NSO MƐKƆ BI

4. My being unemloyed has made you
The woman who is able to come and go,
Before we get something to eat.
Because of the knickerbockers
That you wear
You will slight me and leave me alone,
Go, and remember that I will also go.

5. The children have grown up
And left home,
Leaving the two of us to ourselves
My breasts aren't like they were
In the past .
Yet you think
There is more time ahead of you ,
So you will leave me and hunt around.
Go, but remember I will also go.

6. I am left with only one cover cloth.
When the elite are called
I'm not one of them.
Lovers and relatives
Have all forgotten me,
So you do not count me
Among your people and congregates.
Go, yet do remember I will also go.

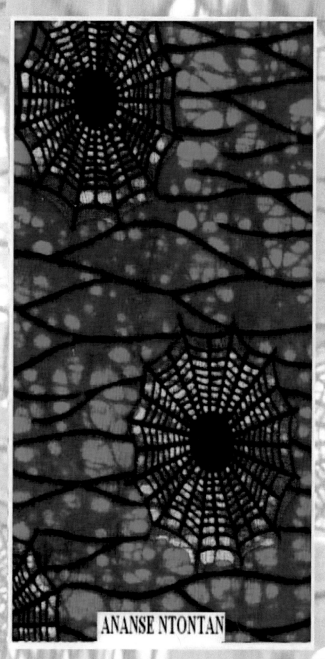

ANANSE NTONTAN

(55) THE SPIDER'S WEB (*ANANSE NTONTAN*)

1. *Kwaku Ananse Akuamoah*
The great sly one who has won a name.
If you haven't read any news about him,
Then your knowledge
Hasn't gone far at all.

2. *Ananse* the Spider
who went to *Nyankonse*
To acquire folklora
From the Creator himself.
He took the Leopard, Python
And Dwarf captive
And packed Bees in a bottle.

3. The husband of *Aso*
was so full of wisdom,
That he became lord in two villages.
Kwaku the Wednesday born
Stood surety for *Aduoku* the Rat
And saved him
From *Agya Sebo* the Tiger.

4. Yet because
of Ananse's good character
He bathed onto his clothes,
And he made
Okwa's children orphans.
The owner of many legs dislikes work.

89

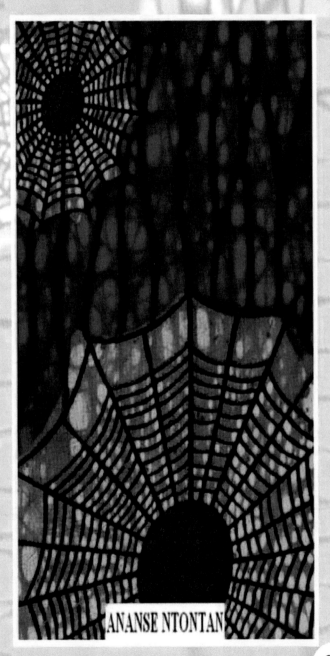

ANANSE NTONTAN

5. How did he get onto the ceiling and
Create a path Into the Squirrel's farm?
For some reason
The Spider sleeps in a mosquito netting
Yet it is not because he is afraid
Of malaria fever.

6. When a little creature misses its way,
And a wren is careless
About the direction of his flight,
They both end up in the spider's netting,
For Father *Akuamoa* the spider
To welcome them.

7. The chief of *Bonwire*
Sent to *Kwaku Ananse*
To ask for knowledge about webbing.
Spider did not hide his knowledge.
The result is that every good *Kente*
Comes from *Bonwire*.

8. Where at all
Does the Spider web come from?
How is he able
To weave between two trees?
What makes it beautiful
Like the rainbow?
Kwaku Ananse Akuamoa the spider,
you inspire fear.

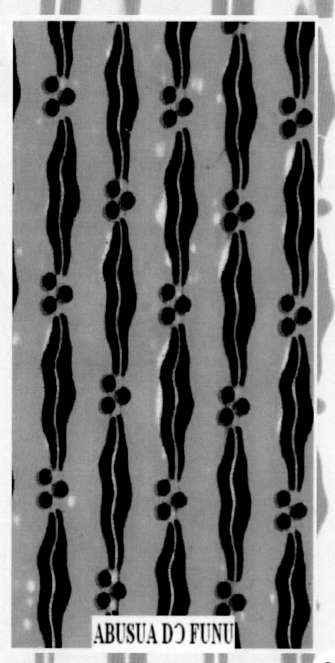

ABUSUA DƆ FUNU

(56) THE CLAN LOVES THE DEAD
(ABUSUA DƆ FUNU)

1. If you have some wealth
And you share it to reach everybody,
Even those you don't know
Will call you uncle.
They draw near you
And you hold their hands.

2. They remember
What you do for them,
And broadcast it for everyone to hear.
"Uncle is there so I will always eat"
Is a song all young women sing.

3. But if you fall into trouble,
And your property is to be sold,
Or your lover, the Government
Puts a chain on your hand,
The song changes completely.

4. No one would concern themselves
About you,
Much less come to your aid.
What they will remember at that time
Is that some mistake
Has landed you at that pass.

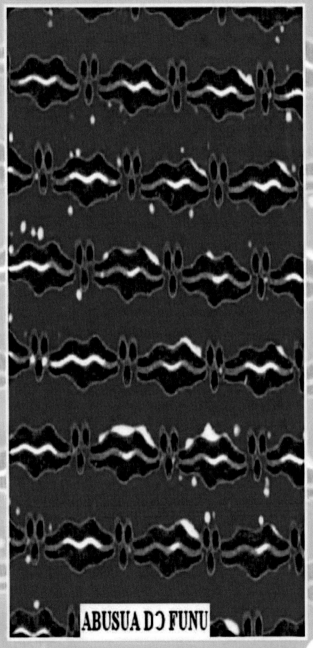

ABUSUA DƆ FUNU

5. If some illness attacks you
And makes you visit the hospital often,
Or makes you bedridden,
Those who will remember you
Will be very few indeed.

6. They will say
Whatever they want about you.
You will be alive, but they will say
You are dead.
What you will eat
And what you will drink
Is nobody's concern,
Nobody's matter at all.

7. If Eternal Death takes you away,
And they don't know what to do
And what to say,
It is then they gather on seats
To think about you,
Because the clan loves a dead body.

8. They will put on black clothes
And red head bands.
Then they weep, blow their noses
And praise you with songs.
They will wrap you in a new cloth
And put you in a nice coffin.
Because the clan loves a dead body.

AMMA SEEWAA

(57) LADY SERWAA
(*AMMA SEEWAA*)

1. *Kwaku Duah's* royal with distinction,
 Who is noted for truthfulness.
 If you want somebody to depend on,
 Because of dependability
 Look for *Amma Seewaa*.

2. She humbles herself for everyone
 And is not anxious in anything.
 If the one you met was proud
 Then it was not *Amma Seewaa*.

3. A good servant
 Who gives water to the donkey,
 And wakes up with joy early at dawn,
 And does all household chores.
 The faithful sojourner *Amma Seewaa*.

4. Because of good training
 She knows her time.
 Her 5 o'clock never turns into 8 o'clock.
 And she doesn't make people
 Waste time on her.
 Amma Seewaa
 Will give you good satisfaction.

AMMA SEEWAA

5. Yet she does not pride herself
Above others.
She humbles herself to learn everyday.
When necessary,
She helps with her experience.
Amma Seewaa shows she is civilized.

6. When you beg water from her
She adds a cake;
She thinks of your friends
And also of your animals.
She has sympathy,
Love and compassion,
Because she is called *Amma Seewaa*.

7. She's the beautiful woman
Who deserves to be taken out.
Yet because of her beauty
She does not overdress.
Her neck, eyes, nose,
And teeth with a gap in them,
Is she not called *Amma Seewaa*?

8. Because of her good speech
And words of advice,
When she appears everybody is happy.
She creates a path
To make a seat for herself,
Because it is not everybody
That is called *Amma Seewaa*.

WONI SIKA A

(58) IF YOU HAVE NO MONEY...
(WONI SIKA A...)

1. Adults give us advice
About many things.
They encourage lovers
To buy their own plates
And to research before setting out.
By so doing, they offer us
A good start in all things.

2. Construction is not an easy task.
From the foundation to the walls.
When the walls stand firmly,
Then come the doors and the windows.
Every stage is important,
So find some money.

3. If you are the strong man
Oga in your village,
Any palm branch or mud wall structure
Is good.
Good foundation, windows and doors?
You use whatever you like as a hat
To top your building.

WONI SIKA A

4. Buildings on the outskirts
Of Obo are beautiful.
They are often made of blocks.
The doors and windows
Are made of glass,
Whoever starts to build his house,
Tries to complete it nicely.

5. If you have no visa,
You can't travel outside.
You can't eat fufu if you have no soup,
If you have no meat or fish,
You can't prepare soup.
So even if your plot of land is at Madina,
Remember if you have no money,
You can't make blocks.

6. You would like people to vote for you
You promise to rebuild the country,
But there is a lot of disorder
In your own house.
Unable to find the mouth of the bag
To insert the calabash?
Dear brother, if you have no money,
Don't make blocks.

HIOB

(59) JOB'S TRIBULATIONS
(*HIOB AMANEHUNU*)

1. The biography of righteous Job,
Is worth studying
And understanding by all.
For his truthfulness and good living,
God blessed him with many things.

2. If he has a good loving wife,
Many beautiful sons and daughters
Who fill his home with laughter and joy,
We believe that is the way it should be.

3. Does Satan communicate with God,
For the Good Lord to allow it,
For Satan to tempt His loving son,
Through many trials and tribulations?

4. If all your children die accidentally,
And you lose all your property,
If your body is covered
with terrible sores,
Would you continue
To serve your God?

HIOB

5. Your loving wife says:
Curse God and die.
Friends reason wisely and declare:
Your many terrible sins
Have caused it all,
On whom would you lean any more?

6. If you receive
No good answers to your prayers,
There's no cure for your terrible disease,
And you are all alone
In your poverty and misery,
Sleeplessness
will not be able to save you.

7. Remember that
Your Redeeming Lord lives, So
The dust-ridden loner will always arise.
He shakes off the dust
And regains his standing,
To the amazement
Of those who ridiculed him.

8. Satan, the enemy will vanquish,
Your soul and spirit will be revived.
Fabulous riches
And loved ones will return,
For you to confess that God is King.

UAC AKANEA

(60) SPOTLIGHT UAC
(UAC AKANEA)

1. We were by ourselves
When Mr. Kwasi arrived.
He brought us Christianity,
Colonialism, and Commerce
As a replacement
for the terrible slave trade.
We probably were content with ourselves,
But Kwasi used liquor and trickery,
Intimidation and flattering
To enslave us all.

2. We won't talk about Colonialism
And Christianity today.
Commerce is our focus now.
Let's go to Mangoase United,
To see what we can find In Spotlight UAC.
Very huge aluminum sheds
Serve as temporary houses
For cocoa awaiting shipment.

3. Cocoa, oil, rubber, stones and gold,
Our merchant fathers buy and hoard them,
For Mr. Kwasi to export them to his country
And when coming back he remembers us.
A machete branded with a sign of hippo,
And sweet-smelling tobacco too.

UAC AKANEA

4. *Tinapa* pilchards
 that make soup delicious,
 "Okumkom" sardines-
 Four pieces that end hunger.
 Flour for making bread, Cheese and milk
 To which Sister is partial,
 Petrol, Kerosene, and other oils too,
 They all helped
 To put UAC in the Spotlight.

5. "Saturday Night" powder
 That women like,
 Andrews Liver Salt
 That heals stomachache,
 Aspirin and phensic
 Who banish headaches,
 Iron metal beds
 That make marriages firm,
 And airtight trunks that allow in no air.
 Can you count the things
 UAC has brought?

6. The UAC Spotlight
 Dresses up the ghost,
 And places her in the store
 To display beauty.
 If we will produce "key soap" here today
 And weave beautiful cloth at Tema,
 Let us print a very gorgeous piece,
 And call it Spotlight UAC.

Made in United States
North Haven, CT
22 May 2022

19425276R00062